Amazing
Mosaics

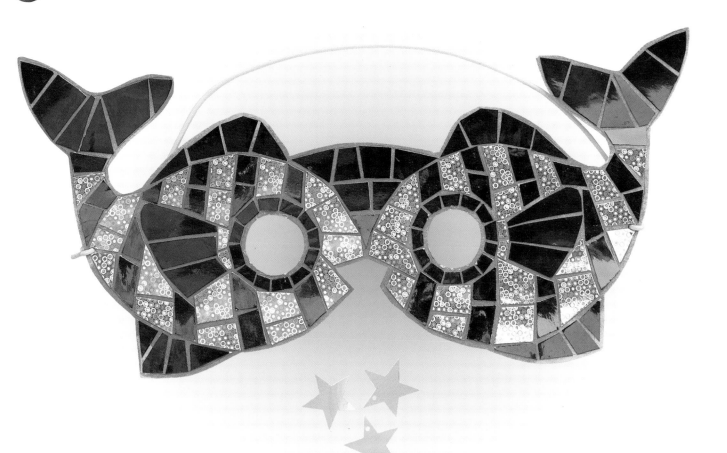

Sarah Kelly

BARRON'S

Contents

 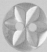 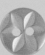

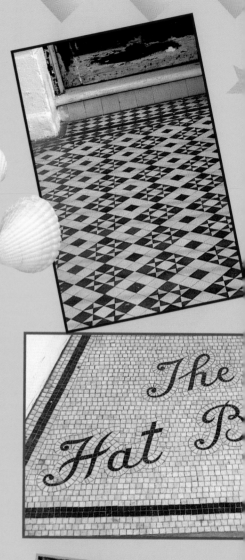

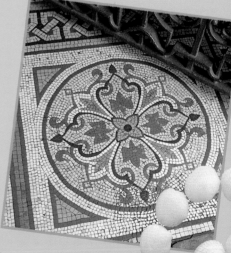

First edition for the United States and Canada published by Barron's Educational Series, Inc., 2000.

Originally a Red Fox Book published in English by Random House Children's Books, 20 Vauxhall Bridge Road, London SW1V 2SA

A division of The Random House Group Ltd, London, Melbourne, Sydney, Auckland, Johannesburg, and agencies throughout the world

Text and Illustrations copyright © 2000 by Sarah Kelly

All inquiries should be addressed to:

Barron's Educational Series, Inc., 250 Wireless Boulevard, Hauppauge, New York 11788 http://www.barronseduc.com

Library of Congress Catalog Card No. 00-101154 International Standard Book No. 0-7641-1623-1

Printed in Hong Kong

9 8 7 6 5 4 3 2 1

Introduction

MOSAICS ARE EVERYWHERE!
Start looking around and you will notice mosaics on floors in **galleries** and **museums**, on the walls of **shops** and **banks**, on doorsteps, in **swimming pools**, and in **subways**. You may even be lucky enough to live in a place that has a mosaic as part of a historical or artistic feature. Mosaic has been used for thousands of years as a **hard-wearing** and **decorative** way of covering all sorts of surfaces. The first mosaics appeared around **3000 B.C.** in what is now **Iraq**, and the **Aztecs** of Mexico used tiny pieces of turquoise stone to cover masks and other ceremonial objects.

Mosaic really became widespread in **Roman** times. At first people used intricate **geometric** patterns to cover the floors of villas and public buildings, but soon they were producing decorative wall panels that **featured** scenes from **legends**, as well as images of the **gods** and **goddesses** they worshipped.

Examples of their work can be seen in **North Africa** and **Italy** and other European countries that made up the huge Roman Empire. Roman mosaic pieces were called *tesserae* and were made of pebbles, chips of marble, or stone in natural earthy colors. Then, in the **Byzantine** period, the use of **tiny pieces** of brightly

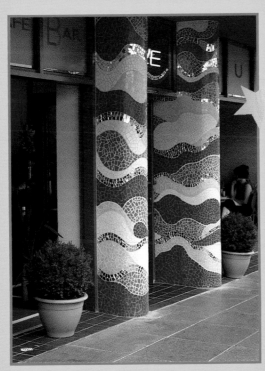

colored **glass**, called *smalti*, was introduced. For the first time, realistic colors and subtle shading could be used to produce beautiful religious images and lifelike portraits of the emperors and other important people. Examples can be found in **Turkey**, **Greece**, and other countries that border the **Mediterranean**.

As time progressed, mosaic work became so **refined** and technically accomplished that sometimes it looked more like painting. The designs became less **decorative** and more **realistic**. By the eighteenth and

nineteenth centuries, people were even doing "**micromosaics**," mosaics that were only a few inches wide!

The art movement known as **Art Nouveau** brought mosaics back to being used as large-scale decorative pieces. In the late nineteenth century an Austrian artist called **Gustav Klimt** designed some of his wall **murals** to include areas of mosaic in swirly, abstract patterns. Later on, a Spanish architect called **Antoni Gaudi** transformed areas of Barcelona with **buildings**, which he covered in fantastic mosaic shapes made out of broken **ceramic tiles.**

Nowadays, mosaic is used as a way of decorating anything from **bathrooms** to **gardens**, using a variety of materials including **glass**, **ceramic**, **stone**, **mirror**, and even **shells**. Lots of different styles, both old and new, can be seen all over the world, so keep your eyes open wherever you go!

Getting started: Materials

In this book most of the mosaics are made from different types of colored paper. Some of these you may already have or be able to find around the house. Most art shops and stationery stores stock a variety of colored and special paper. Start gathering together the following materials now, so you will have a good collection when you begin the projects.

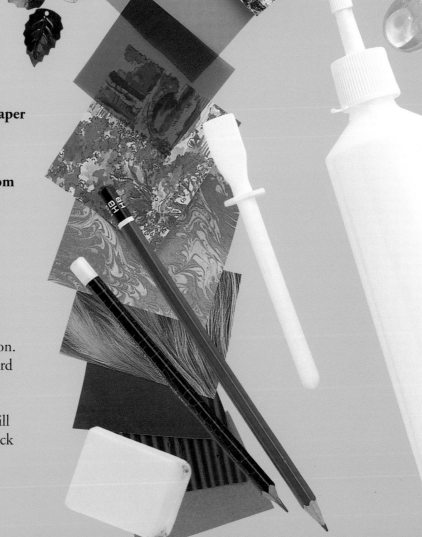

PAPER
- **Plain paper in bright colors**
- **Glossy magazines**
- **Patterned paper such as wrapping paper or wallpaper**
- **Colored foil**
- **Colored cellophane**
- **Candy wrappers made from foil or cellophane**
- **Holographic foil paper**
- **Fluorescent paper**
- **Handmade paper**

CARDBOARD
Most of the projects use thin cardboard as a base to work on. You can buy colored cardboard or use acrylic paint or ink to color plain white cardboard. Don't use powder paint; it will start to smudge when you stick on the paper pieces.

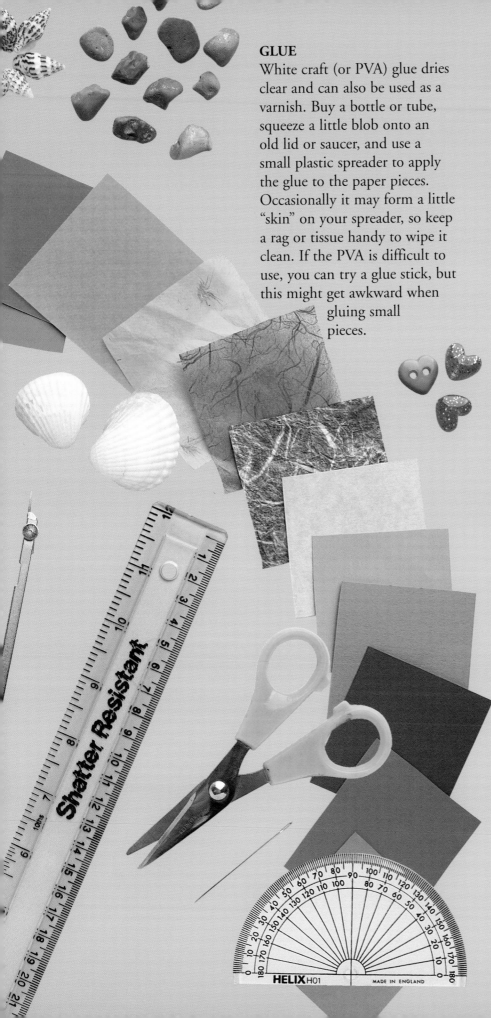

GLUE

White craft (or PVA) glue dries clear and can also be used as a varnish. Buy a bottle or tube, squeeze a little blob onto an old lid or saucer, and use a small plastic spreader to apply the glue to the paper pieces. Occasionally it may form a little "skin" on your spreader, so keep a rag or tissue handy to wipe it clean. If the PVA is difficult to use, you can try a glue stick, but this might get awkward when gluing small pieces.

OTHER MATERIALS

- **Sequins** Different colors and shapes (shells, hearts, and stars if you can find them) can be bought from craft stores.
- **Flat buttons** Cheap odd ones can be found in markets and thrift shops, or ask anyone you know who sews if they have any spare ones.
- **Shells** Use tiny ones, or break bigger ones into pieces by putting them into a strong plastic bag and hitting it with a hammer (ask a grown-up to help you with this). Raid your shell collection or buy bags of shells from gift shops.
- **Small gravel stones**
- **Beads**
- **Dried legumes and seeds** Try lentils, split peas, small beans, and sunflower and other seeds.
- **Glass nuggets** These can be bought from craft stores or shops that sell candles.

TOOLS

- **Scissors** A large pair and a smaller pair of needlework scissors for snipping more complicated shapes.
- **Pencil** A hard, or H, pencil is good for making fine, clean lines.
- **Ruler**
- **Compass** for drawing circles.
- **Protractor** for marking angles.
- **Hole puncher** for making circular pieces.
- **Eraser**
- **Felt-tip pen**
- **Tracing paper**
- **Strong needle** for making holes.

Getting started: Techniques

 No matter how experienced you are, it does take time to make a mosaic, but the longer you spend and the more you practice, the better the result will be. You may find it awkward at first, especially if the pieces are quite small, so using larger pieces may help.

Before you start, read each project through carefully to understand exactly what needs to be done at each stage. The projects are designed to get more challenging as you become more practiced in the mosaic technique, so try to work through the book and not skip straight to the more complicated ones at the end! New techniques are introduced project by project, but there are a few basic things that you need to think about right from the start.

DRAWING
Always draw your outlines in pencil. Don't make the line too dark and heavy, and erase any lines that are showing when your mosaic is finished. If the background color is very dark, use a white or light-colored pencil instead.

The templates at the back of the book will help you when you start doing the projects. You can use them two ways. Either you can photocopy the page, cut out the template, and draw around it on the sheet of oak tag, or you can trace it. Take a sheet of tracing paper, then draw around the template with a pencil. Lay the tracing paper pencil-side down on the cardboard, secure it at the top with pieces of masking tape so that it doesn't slip, and trace over the design – it should come out perfectly on the oak tag!

CUTTING
Cut strips of paper to the width given in each project and then snip them into squares. Don't worry if they're not completely even all the way along or the squares aren't perfect.

When you are laying squares around curves, you need to cut them so they fit together properly. Cut the squares so that they are wider at the top than at the bottom, and stick them down with the widest part on the fattest part of the curve.

As the space remaining gets smaller, you need to cut the squares into specific shapes to fit. You can do it by eye, or by laying the square over the space and then marking with a pencil where you need to cut it.

GLUING

Before you start gluing, protect your work surface by putting down newspaper. Use a small amount of glue on the plastic spreader and wipe it frequently to keep it clean. You'll get the best results by applying glue to each piece individually, but if you find this is too awkward, then you could try this method: spread some glue onto a small area of the cardboard and push the pieces straight onto it. Do this only if you're using PVA and if you have used acrylic paint or waterproof ink; otherwise the color might run.

PLACING

Always lay the pieces next to each other, working in lines. Leave small gaps between each piece and try to keep the gaps the same size throughout your mosaic. Do any important details like eyes or fins first. Always do the foreground before the background.

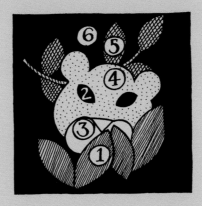

Start by working around the outline of your subject and then work inward in "rings" so that the shape remains clear when the mosaic is finished.

After a while, you will start to develop a rhythm when laying the pieces and learn to see what shapes will fit where. Try to keep the lines flowing, and don't be afraid to go over a pencil line or cut a corner if it looks more natural that way.

BACKGROUNDS

There are two ways you can do the background. One way is to follow the outline of the subject and work outward. The other way is to lay the pieces in horizontal or vertical lines and cut them to fit where the line hits the edge of the subject.

The project instructions will suggest oak tag colors for the backgrounds to your mosaic, but when you are making up your own designs, make sure that the oak tag color is not the same as any of your mosaic pieces, or they will not be visible. Remember, mosaics are not made by machines, so there will always be a bit of perfectly natural human error involved. They are not meant to be completely perfect, so don't worry if some lines are not straight or some pieces overlap. All these things give your mosaic a unique charm and make them look much more authentic! Your finished pieces don't need to look exactly like the examples in the book to be attractive. Tackle each project in your own way and learn the best way of doing things as you go along. You can use the ideas as inspiration for projects of your own that you can develop in your own style. The most important thing is to have fun.

Golden sun

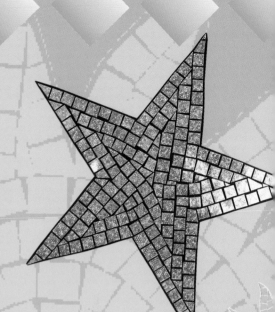

Simple mosaic techniques are used to create a beautiful big sun with fiery rays, or a sparkling star.

YOU WILL NEED

- A sheet of thin white oak tag
- Yellow paper
- Scissors
- PVA glue and small plastic spreader
- Pencil and eraser

1 Draw the outline of a sun in the middle of the oak tag. Make it as big as you like!

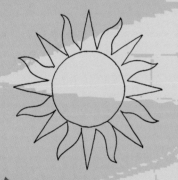

2 Cut the yellow paper into strips about 1/2 in. (1–1.5 cm) wide and then cut them to make lots of little squares. The bigger your sun, the more squares you'll need.

3 Starting with the circular part of the sun, glue the squares around the outer edge, leaving a small gap between each one.

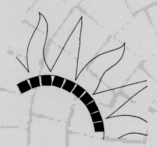

4 Continue working inward in "rings" of squares. As you get farther into the circle, cut the edges off the squares so they fit together snugly.

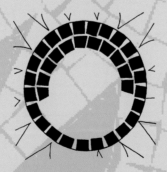

5 Now move on to the sun's rays. Do the outer edges first, starting with the wider part nearest the circle. Cut the squares into smaller shapes to fill the narrow spaces at the end and middle of each ray.

6 Do the rest of the sun's rays in the same way.

7 When your sun is finished, erase any pencil lines that are showing, cut it out, and hang it on your wall. It will brighten up your room even on the grayest day!

8 Try making a star shape in the same way with silver foil or sparkly holographic paper.

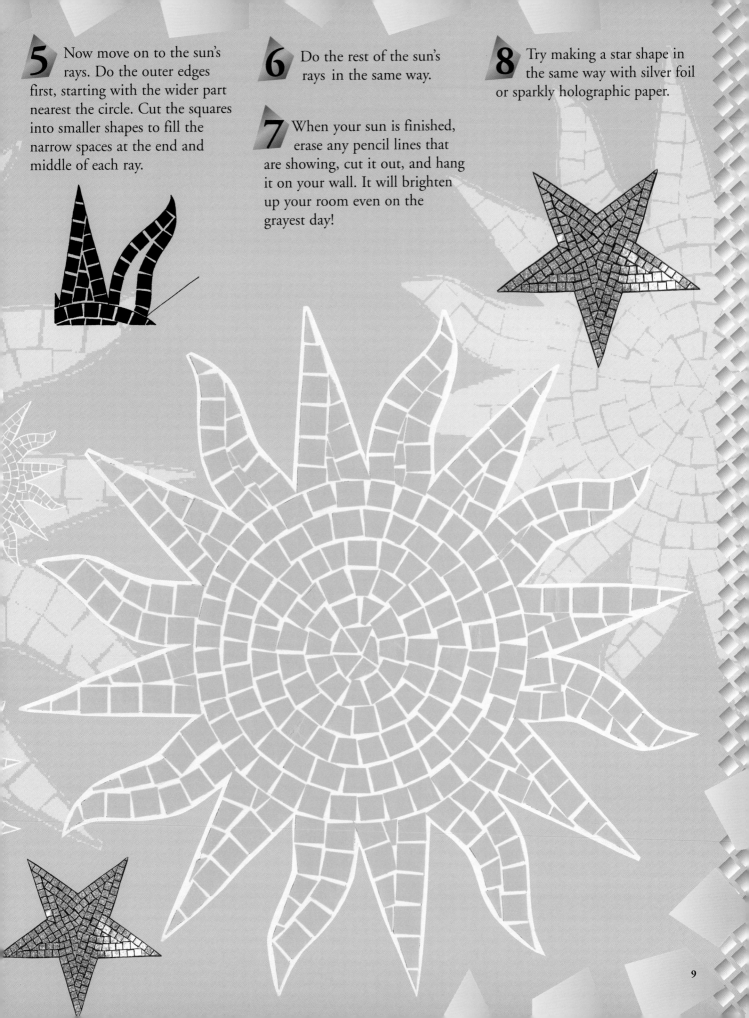

Knobbly seahorse

Use a natural material, like pieces of broken shell or tiny pebbles, to make a lovely knobbly seahorse.

YOU WILL NEED

- **A sheet of thick cardboard 11 3/4 × 6 3/4 in. (30 × 17 cm)**
- **Blue and green acrylic paint**
- **Tracing paper**
- **Broken shells or very tiny stones**
- **A small flat button**
- **PVA glue and small plastic spreader**

1 Paint the sheet of oak tag, mixing streaks of blue and green to get a watery effect.

2 Choose shells or stones that are roughly the same color, and wash and dry them carefully. Break up the shells by putting them into a strong plastic bag and smashing them with a hammer (ask a grown-up to help you with this).

3 Trace the seahorse template on p. 38 onto the sheet of oak tag (see p. 6).

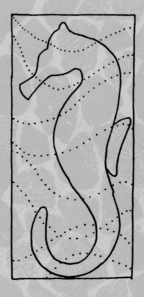

4 Glue on the button for the seahorse's eye.

5 Start to fill in the seahorse with the shell pieces or stones. Do the head first and work down the body, leaving a small gap between each piece. Always glue one piece next to another. Don't worry if you go over the edges of the outline.

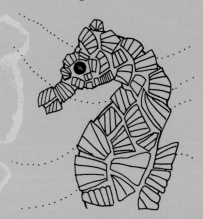

TIP
Use smaller pieces in the narrower areas such as the nose and tail and bigger pieces for the body.

6 Leave your mosaic flat for a few hours until the glue has completely dried.

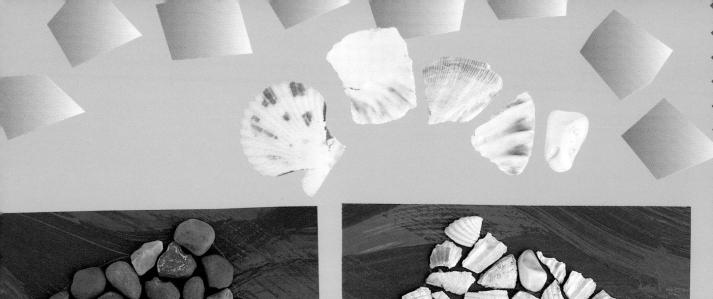

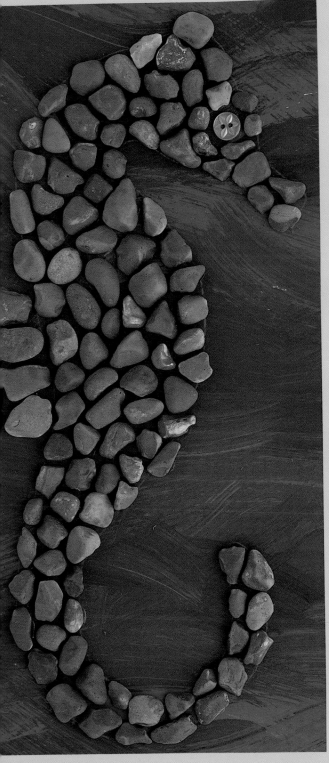

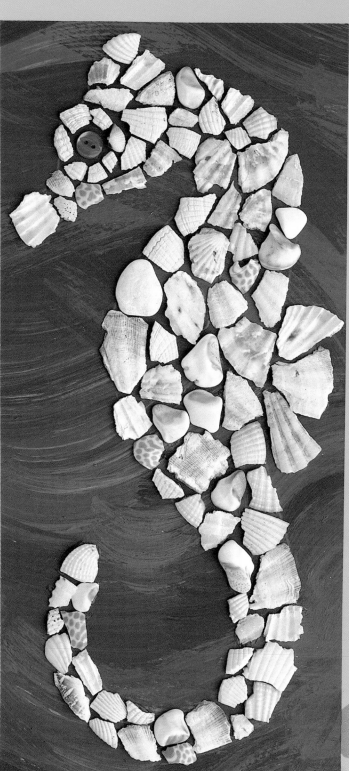

Crazy paving crab

You only need to use two colors to make a picture with a background. Fill in a simple animal shape with irregularly shaped pieces using a wonderfully wild mosaic technique.

YOU WILL NEED
- **A sheet of white oak tag the size of this page**
- **Old glossy magazines**
- **Scissors**
- **PVA glue and small plastic spreader**
- **Pencil and eraser**

1 Trace the crab template on p. 39 onto the oak tag (see p. 6).

2 Cut out blocks of turquoise and orange from the magazines. Try to find different textures within the colors (shiny, rough, patterned, or even colors with writing on them) to make your mosaic look lively and exciting.

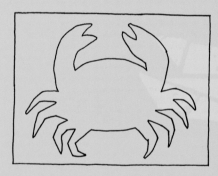

3 Cut the blocks of color into triangles, squares, rectangles, and every shape in between by holding the paper and cutting off pieces randomly. The pieces need to be different shapes and sizes but no bigger than about 1 1/4 in. (3 cm) square. Start by making about 50 of each color – you can always make more if you need to.

4 Do the crab first. Start by sticking pieces of paper at the ends of the legs and move toward the body. Don't worry if you go over the pencil outline, but don't give your crab an extra leg by mistake!

5 Once the legs are finished, move on to the body, working from the outside and moving in. Try to keep the gaps between each piece as small as possible, although they will vary, as you are using irregular pieces.

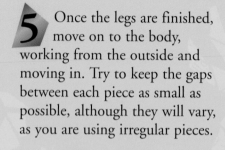

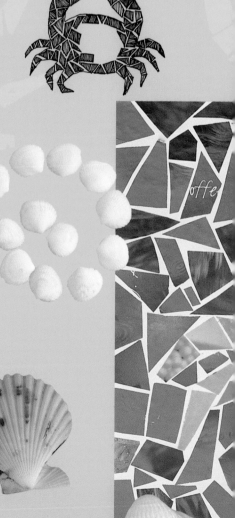

This style is very similar to the way in which the Spanish artist and architect ANTONI GAUDI worked. He had ceramic tiles with beautiful patterns made especially for him and then broke them up and used them for mosaic. He used this technique to cover the inside and outside of the houses he designed. He also designed an entire park in Barcelona called Parc Guell that features mosaic benches as well as a huge dragon sitting on a staircase.

6 As you reach the center of the body, you may have to cut special shapes to fit into the small spaces left. Pick a piece that looks as if it will almost match, then trim it to fit. Continue until the animal shape is complete.

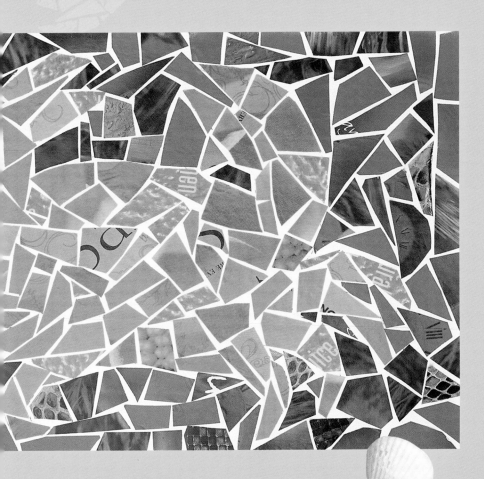

7 Now move on to the background. Do the area next to the crab first, using small pieces for the spaces between the legs, and moving outward. When you reach the edge of the oak tag, don't go right up to it but leave a small border of about 1/8 in. (3 mm).

8 Erase any pencil lines that are showing and reglue any loose corners that may have come up.

9 Try making another animal shape, like the scorpion on p. 40, or design one of your own!

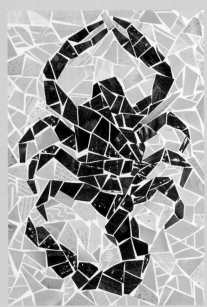

Animal bookmarks

Design and create your own animal bookmark using mosaic squares in two or three colors. Use other types of colored paper for different effects.

YOU WILL NEED

- **A sheet of thin colored oak tag (choose a color you're not using for the squares)**
- **Colored paper (plain-colored paper, fluorescent, or handmade paper)**
- **Scissors**
- **PVA glue and small plastic spreader**
- **Ruler**
- **Pencil and eraser**

1 Using a ruler and pencil, draw an 8 1/4 × 3 1/8 in. (21 × 8 cm) rectangle lightly on the oak tag.

2 Decide on an animal (or anything you like!) that has a nice long shape and will fit into the rectangle. Practice drawing it on a piece of scrap paper. If you make parts of the animal break out of the shape, it will make it look much more exciting! When you are happy with your design, draw it in the rectangle with a pencil.

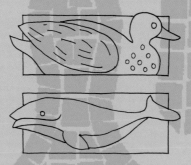

3 Choose two or three colors for your animal. Cut the paper into strips about 1/4 in. (5 mm) wide and cut them into squares.

4 Start by filling in the animal shape. Starting from the outside, glue the pieces in a continuous line and move in. The aim of mosaic is to get a sense of flowing lines, so when you come to a bend or a corner, cut the square into whatever shape you need to fit, so that your line can continue smoothly. As you move inward and the spaces become smaller, you will need to do this more often. Continue until the animal shape is complete.

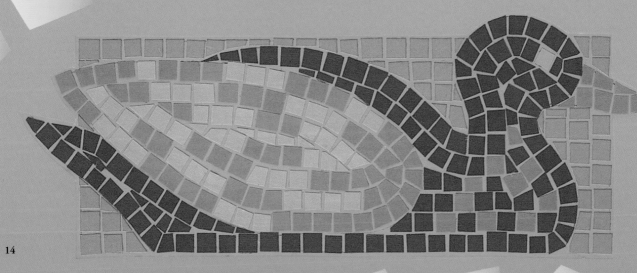

5 Now choose a different color for the background and cut out squares as before.

6 To contrast with the flowing lines of your animal, glue the squares onto the background in horizontal lines, moving inward from the outside edges. When you come to the edge of your animal shape, cut a square to fit into the space, then carry on with the next line.

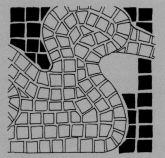

7 When your mosaic is completely finished and you have erased any pencil lines that are showing, carefully cut out your bookmark leaving a small border around the edge.

8 Make lots more bookmarks with different designs. They make great presents!

TIP
Make patterns on your animal by gluing down different colored squares every so often to make stripes or spots. Don't forget to include a different colored square for the eye.

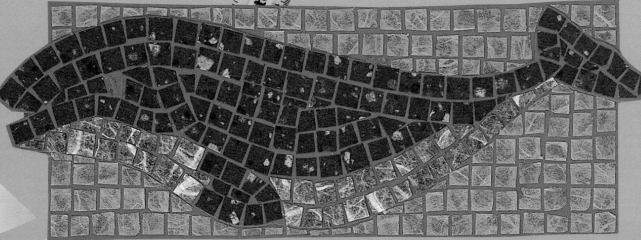

Sparkly flower frame

Decorate a flower-shaped frame with a glittering mosaic of sequins and buttons.

YOU WILL NEED

- **A sheet of yellow oak tag at least 9 3/4 × 19 1/2 in. (25 × 50 cm)**
- **A piece of cardboard**
- **Flat buttons in pink, red, and yellow**
- **Sequins in gold, silver, and pink. Try to find shell- and heart-shaped ones.**
- **Scissors**
- **Pencil and eraser**
- **PVA glue and small plastic spreader**
- **Double-sided tape**
- **Compass, protractor, and ruler**

1 Use the compass to draw a 4 in. (10 cm) diameter circle inside a 9 1/2 in. (24 cm) diameter circle (compass arms should be 2 in. [5 cm] and 4 3/4 in. [12 cm] apart respectively) on a piece of yellow oak tag.

2 Use a protractor to mark off eight 45-degree angles on the inner circle and extend the lines out to the edge of the outer circle with a ruler. This will make eight petals for your flower.

3 Make the segments into petals by drawing semicircles at the ends, then cut out the flower shape. You will need to cut out the middle circle as well. Use sharp scissors to make a hole first, then cut out the inside of the circle (ask a grown-up to help you with this).

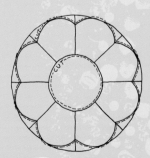

4 Turn the frame over, so that you are working on the side without the pencil lines. Arrange the buttons and sequins on the flower. Place them in rings starting from the outside and working inward. If you have mixed or odd buttons, it might be easier to design each petal individually.

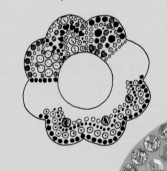

5 When you are happy with your design, leave the pieces where they are and start gluing each one down. This way you make sure that everything is in the right place and that it all fits together properly.

6 Work from the outside and move in, but if you have designed a border around the inside of the frame, do it first or you might run out of room!

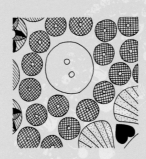

7 Toward the center, you will probably need to leave bigger gaps between the pieces. Don't worry about it. Just try to incorporate them into the design!

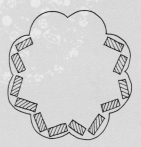

8 When the frame is finished, leave flat for a few hours until the glue has completely dried.

9 Place the frame on top of a piece of cardboard, and use it as a template to make the back of the frame. Draw around it and mark one petal on both pieces so you can get a perfect match when you glue them together. Cut it out (but remember, you don't need a hole in this piece).

10 Put little strips of double-sided tape on the inside of the frame on the edges of six petals (leave two unstuck to give you room to slide in a photograph) and stick the two pieces of the frame together.

11 Choose a photo that fits the size of the frame. Put a piece of double-sided tape on the back to keep it firmly in place, then slide it in.

12 Try making different shaped frames in the same way. You can make a heart shape in red and pink, or a shell shape decorated with tiny shells.

17

Pretty picture frames

Make a rectangular frame in brightly colored geometric designs inspired by ethnic patterns.

MOROCCAN FRAME

YOU WILL NEED
- **A sheet of plain cardboard**
- **Dark blue, bright yellow, and brown paper**
- **Patterned paper (wrapping paper, wallpaper, or old glossy magazines) in turquoise blue. Paint some pale patterned paper with ink if you can't find any in the right color. Use ink rather than paint so that the pattern will show through.**
- **Very sharp hard pencil**
- **Scissors**
- **Small sharp scissors**
- **PVA glue and small plastic spreader**
- **Ruler**
- **Double-sided tape**

1 Photocopy the Moroccan frame template on p. 41 and glue it onto the piece of cardboard, but don't cut out the frame just yet.

2 Using the small scissors, very carefully cut out the star, square, and rectangle at the bottom of the template. Glue them onto a piece of cardboard and cut them out as accurately as you can; these are the templates for your tiles.

3 Draw around the shapes on the colored paper. Keep sharpening your pencil so that the lines are as clear as possible. Cut out the shapes using the small scissors. You will need 14 yellow stars, 14 brown stars, 56 dark blue rectangles and 28 turquoise squares. This is going to take some time, but persevere – it will be worth it! Maybe you can ask a patient friend or parent to help you out!

4 Take four of the brown stars and mark them into quarters using a ruler and pencil. Cut out one quarter from each star. These quarters will go on the outside corners of the frame, and the remaining three quarters will go on the inside corners. Cut the rest of the brown stars into halves.

5 Cut 14 of the turquoise squares diagonally in half to make 28 triangles.

6 When all the shapes are cut out, start gluing them over the corresponding shapes marked on the frame. Begin at a top corner and work around, always gluing one tile next to another. Don't panic if they don't interlock perfectly – neither do real Moroccan mosaic tiles!

7 When your mosaic is finished, cut around the outside of the frame, leaving a border of 1/8 in. (2–3 mm). It doesn't need to be completely straight. Cut out the middle of the frame in the same way as described in the flower frame project (p. 16).

8 Use the frame as a template to make the back of the frame from another piece of cardboard. Use strips of double-sided tape to join the two halves of the frame on three sides. Leave the top open so you can slide in your photo or picture.

The term for the Moroccan style of mosaic is ZILIJ. It is made from tiles in specially cut shapes such as stars, hexagons, triangles, diamonds, and other geometric shapes. The tiles are all given special names and they fit together in a variety of patterns, which must be learned by the craftsmen who make them. They are used to decorate walls and floors in buildings and gardens.

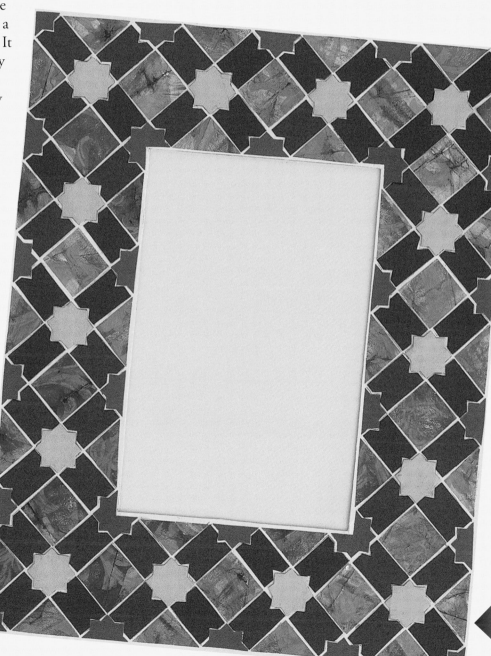

AFRICAN FRAME

YOU WILL NEED

- **A sheet of dark red oak tag at least 9 1/2 × 15 in. (24 × 38 cm)**
- **Orange, black, and white paper**
- **Tracing paper**
- **Masking tape**

1 Trace the African frame template on p. 42 onto half of the sheet of oak tag (see p. 6).

2 Cut the black and orange paper into strips just under 3/8 in. (1 cm) wide and then cut them into squares. You will need 28 black squares and lots of orange ones.

3 Cut the white paper into strips of about 3/16 in. (3–4 mm) wide from the white paper and then cut them into squares.

4 Mark four of the black squares diagonally into quarters, then cut one quarter from each as you did with the stars in the Moroccan frame. Cut ten more black squares diagonally in half to make 20 triangles. Cut 27 orange squares in the same way to make 54 triangles. These will go along the edges of the frame.

5 Glue the black tiles down first to create the center of each diamond shape. Next, stick the orange tiles around them, using eight orange squares to surround each black one. Where the diamond pattern meets the edge of the frame, use the triangle shapes to fill in the spaces.

6 Fill in the lines around your diamond shapes using the white squares (or leave them blank if it is too awkward).

7 When your design is finished, cut around it and put it together in the same way as the Moroccan frame.

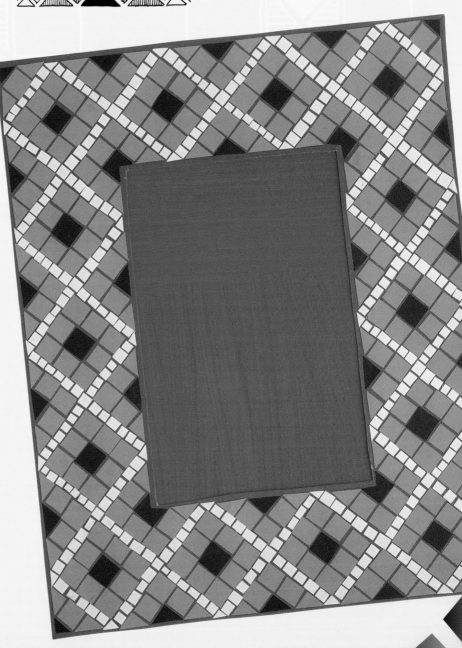

AMERICAN PATCHWORK FRAME

YOU WILL NEED
- **A sheet of oak tag**
- **Old glossy magazines, wrapping paper, or wallpaper**

1 Photocopy the American patchwork frame template on p. 43 and glue it onto half of the sheet of oak tag.

2 Choose a color scheme for your frame and cut out blocks of patterned paper. You are aiming for a patchwork quilt effect made out of lots of scraps of fabric, so choose lots of different patterns.

3 Cut the paper into squares that are smaller than the squares on the design.

4 Make the triangles by cutting the squares diagonally in half and then half again.

5 Fill in the design, using color and pattern randomly. For variety, substitute bigger "half" triangles for the smaller "quarter" ones.

6 Cut out and put together like the other frames.

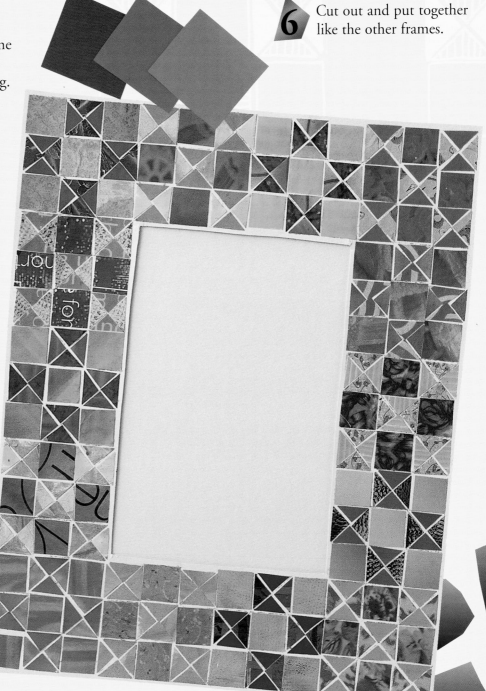

Stained glass window sticker

Create a stunning starfish sticker for a window, using pieces of colored cellophane to give a stained glass effect.

YOU WILL NEED

- A sheet of white paper
- Clear sticky-back plastic (available from stationery stores)
- Cellophane, colored acetate, or cellophane candy wrappers in orange and light blue or green
- Pencil
- Two black felt-tip pens, one thick and one thin
- Scissors
- Masking tape
- Compass or small plate (about 7 3/4 in. [20 cm] diameter)
- PVA glue and small plastic spreader

1 Draw a 7 3/4 in. (20 cm) circle on the white paper using the compass or plate.

2 Draw a chunky starfish shape in the circle, making sure the ends of the legs touch the edges of the circle.

3 Go over the lines with the thin felt-tip pen. Draw lines going down the center of each leg with the thick felt-tip pen.

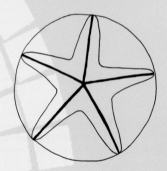

4 Draw some thin lines between the legs of the starfish. These will act as a guide for placing your mosaic pieces.

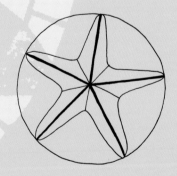

5 Cut a piece of the sticky-back plastic slightly bigger than the circle. Tape it (paper side down, shiny side up) to your drawing using little strips of masking tape. You should be able to see your drawing through the sheet of film.

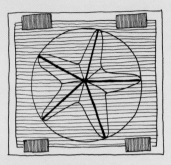

6 Cut the orange cellophane into strips about 1/2 in. (1.5 cm) wide. Cellophane is a floppy material to work with, so cut each strip into smaller strips about 1 1/2 in. (4 cm) long.

7 Start at the top of each starfish leg and work down, doing one half at a time. Cut a triangle to fit the top of the leg and glue it down, leaving a gap where the thick center line is. Cut the pieces to fit the spaces. Do this by eye if you feel confident! If not, then lay each cellophane strip over the area you are filling, mark the lines with the thin felt-tip pen, and cut it out.

8 As you get nearer to the bottom, use the lines you drew in step four as a guide to cutting the right shapes for the spaces. You will need to cut angled or triangular pieces to do this.

9 Do the other half of the leg in the same way, then work around the rest of the starfish.

10 Cut out strips just over 3/8 in. (1 cm) wide from the blue or green cellophane and cut them into squares. Fill in the background starting at the outside of the circle and moving in. As you get farther in, cut the squares to fit around the curve. Cut out whatever shape you need to fit in at the bottom.

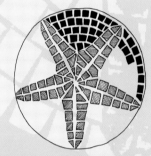

11 Allow to dry. The glue is dry when it becomes transparent. This may take a couple of days, as it is sandwiched between two pieces of plastic. When this is done, cut another piece of plastic roughly the same size as your original. Peel off the backing paper and stick it carefully over your cellophane mosaic.

12 Cut out the mosaic circle with the scissors, peel off the backing paper, and glue it onto a window where the sun can shine through it.

Shiny fish mask

Show off your mosaic skills with this eye-catching fish mask. Holographic and shiny colored papers make it shimmer when it catches the light!

YOU WILL NEED
- **A sheet of oak tag**
- **Tracing paper**
- **Silver holographic paper**
- **Blue and green shiny holographic paper**
- **Turquoise ink or acrylic paint**
- **Small scissors**
- **PVA glue and small plastic spreader**
- **Piece of thin elastic**
- **Two small silvery beads (optional)**
- **Strong, sharp needle**

1 Trace the fish mask template on p. 44 onto the sheet of oak tag (see p. 6). Cut it out and use small scissors to cut out the eye holes.

2 Paint the front of the mask with ink or paint, but mix it first with water so that you can still see the lines through it.

3 Cut the blue paper into strips about 1/4 in. (5 mm) wide and cut out little rectangles with slanted sides.

4 Glue the rectangles around the eyes, putting the narrower edges against the outside part of the circle.

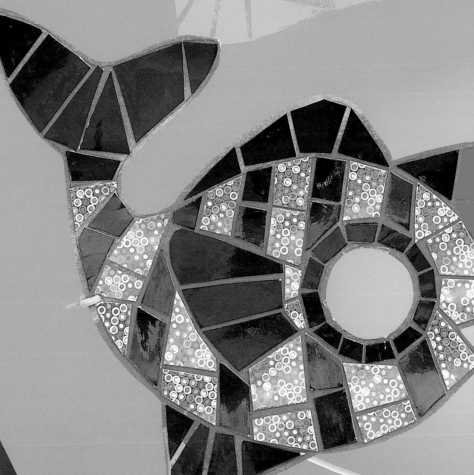

5 This time, instead of filling the spaces with lots of squares, you must cut shapes to fit the spaces. Start with the fin next to the eyes. Cut a long thin wedge shape in the blue paper, then lay it over the fin and mark with a pencil the places where you need to cut so that it fits perfectly.

6 Alternate green and silver stripes in the same way, using squares or rectangles cut to fit. Start with the head, using silver, and work across.

7 When the body is finished, do the outside fins and the tail with blue paper.

8 Repeat steps four to seven on the other side. When both fish are complete, do the bridge across the nose in horizontal lines of green.

9 Allow the mask to dry for a couple of hours under a heavy weight, such as a pile of books, to keep it from curling up.

10 Pierce a hole in either side of the mask between the fish's bottom fin and tail, using the needle (ask a grown-up to help you with this).

11 Measure a piece of elastic that will hold the mask firmly on your head. Thread one of the beads onto the elastic and tie it on securely. Thread the elastic through the front of one of the holes, so the bead is visible at the front of the mask. Now thread the elastic through the back of the other hole and tie a bead on the other end, so the bead is visible on the other side (figure a). If you don't have any beads, just thread the elastic through the holes and tie the ends (figure b).

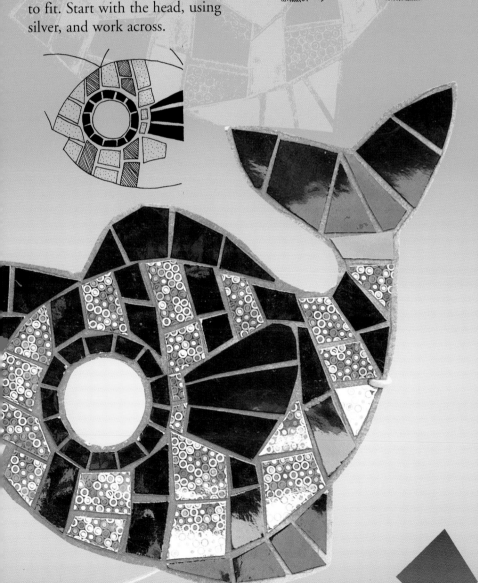

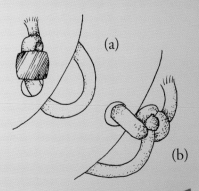

(a)

(b)

Ripped paper picture

Ripping the paper gives a much softer effect. Use this new technique to make a spotty giraffe in a bright sunny African landscape.

YOU WILL NEED

- **A sheet of dark brown oak tag**
- **A sheet of cream-colored paper**
- **Colored paper in two shades of blue, three shades of brown, some orange, yellow, black, and lots of greens**
- **PVA glue and small plastic spreader**
- **Pencil**

1 On a photocopier enlarge the template of the giraffe on p. 45 and trace it onto the cream-colored paper (see p. 6). Then, using small tearing movements with your forefinger and thumb as you follow the outline around, tear out the giraffe and glue it onto the brown oak tag.

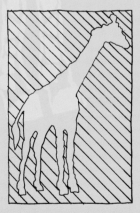

2 Draw the background. Create an African landscape with grass, trees, and distant mountains.

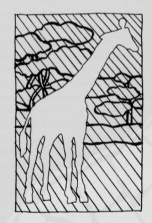

3 Start ripping some pieces from the brown paper for the giraffe's body. Do it in the same way as you did when you were using scissors – by making strips and then squares. Because you are not using scissors, you will get pieces of many different shapes.

4 Begin by gluing the pieces on the giraffe's body, working from the head and moving downward. Use smaller pieces on the head, not forgetting an eye, then make the pieces bigger as you work down the body. This technique should make the giraffe's spots look realistic.

5 Use smaller pieces to do the legs, and as you go down, start to use orange or light brown pieces. Do the hooves with black pieces ripped to the correct shape.

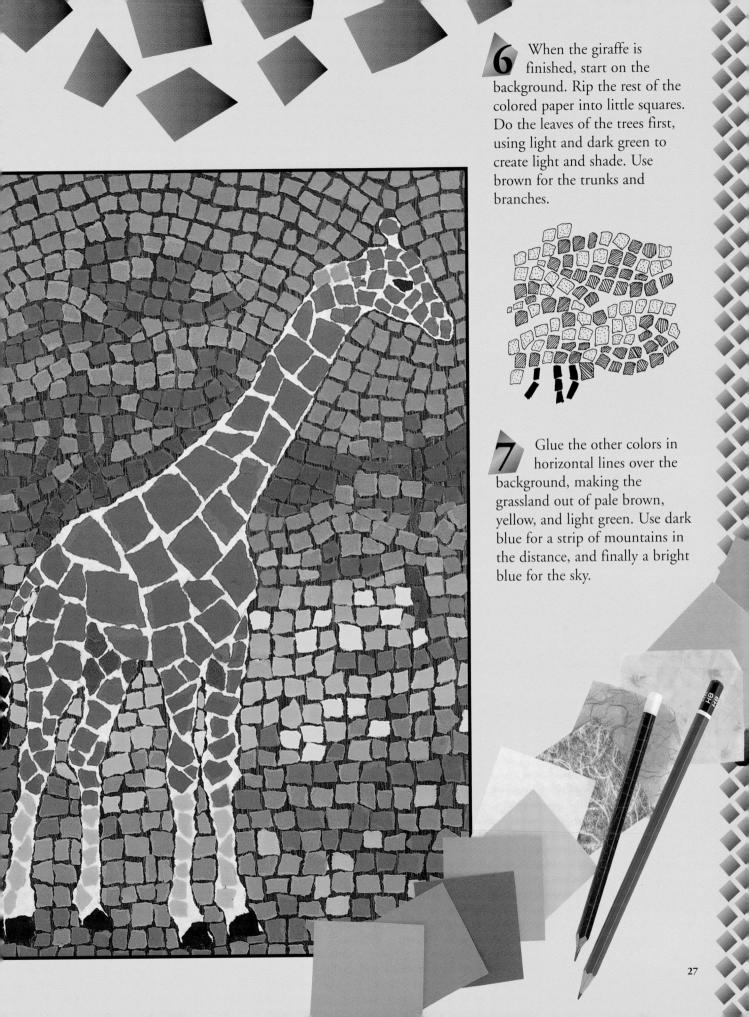

6 When the giraffe is finished, start on the background. Rip the rest of the colored paper into little squares. Do the leaves of the trees first, using light and dark green to create light and shade. Use brown for the trunks and branches.

7 Glue the other colors in horizontal lines over the background, making the grassland out of pale brown, yellow, and light green. Use dark blue for a strip of mountains in the distance, and finally a bright blue for the sky.

Fantastic fish mobile

Turn your room into a colorful ocean scene with this fabulous fish mobile. Use tiny circles in colored paper to create the effect of shimmering scales on a shoal of brightly patterned tropical fish.

YOU WILL NEED

- A sheet of colored oak tag
- Tracing paper
- Colored paper in lots of bright colors
- Silver, gold, and colored foil (or foil candy wrappers)
- A hole puncher
- PVA glue and small plastic spreader
- Scissors
- Cotton thread or thin wool
- Strong needle
- Thumbtacks

1 Choose one of the fish templates on p. 46 and 47. Trace around it onto the sheet of cardboard (see p. 6).

2 Lightly pencil-in the details such as the eye, the fin, and the pattern.

3 Decide on the colors you want your fish to be and use the hole puncher to make lots of circles from the colored paper and foil. Do each color separately. Store the circles in old lids or little pots, keeping each color separate.

4 Start by filling in the eye and the side fin. Make the fish's eye by first gluing down a large black circle, then a smaller circle in another color and finally a smaller black circle on top of one another. See the tip box for the different ways to make the fins.

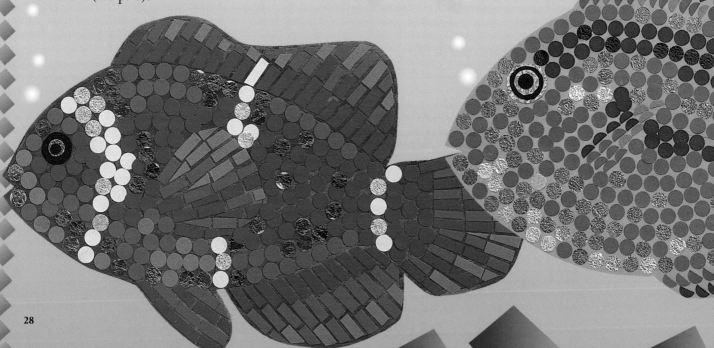

5 Make the body of the fish by starting at the mouth and gluing circles around the outside. Change color when you come to a line indicating a new pattern. Don't forget to use foil circles occasionally to make your fish sparkle.

6 Continue working inward in the same way, starting and finishing each line at the mouth, until the whole body is filled. If a circle is too big to fit into a space, just overlap the ones around it. Continue until the fish body is complete.

11 Using the other templates, make lots more fish in different patterns and colors. You can try drawing some of your own, too! Vary the lengths of thread for each fish so they hang at different heights. You could also make whales, seahorses, and starfish if you like.

7 Fill in the top and bottom fins and the tail using one of the methods described in the tip box.

8 When one side of the fish is finished, cut it out, leaving a border of about 1/8 in. (2–3 mm). Turn the fish over and do the other side. You can use the same colors and patterns, or design new ones.

9 To attach a string to the fish so that it can hang from the ceiling, pierce a hole at the top using a strong, sharp needle (ask a grown-up to help). Hold the top of the fish lightly between your thumb and forefinger and decide on the angle you like best, and then make a hole where your fingers were.

10 Thread a piece of cotton or thin wool through the hole and tie a small loop in it. Stick it to the ceiling with thumbtacks.

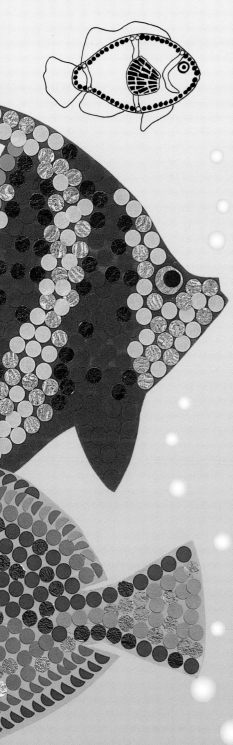

YOU CAN MAKE THE FINS AND TAIL IN THREE WAYS:

1 Use circles as you do on the body, but use different colors so they really stand out.

2 Cut the circles in half and arrange them in lines, diagonally for the top and bottom fins, and in a fan shape for the body fin and tail.

3 Use tiny strips of paper in the same way as example two. For the top and bottom fins, cut the first strip nearest the fish's body with a diagonal end so they radiate out at an angle. Cut long thin triangles to fill in the gaps on the body fin and tail.

Decorated jungle box

A sumptuous design of lush jungle leaves revealing glimpses of colorful animals turns an old shoe box into a treasure chest.

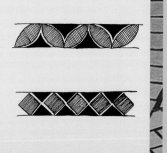

YOU WILL NEED

- **Shoe box (preferably white) with lid**
- **Colored paper in lots of different colors**
- **Dark blue acrylic paint (or waterproof ink) and a thick brush**
- **Plain white paper**
- **PVA glue and small plastic spreader**
- **Scissors**
- **Pencil and paper**
- **Light-colored pencil**
- **Sticky-back paper (holographic if possible)**

1 Prepare your shoe box and lid by gluing strips of white paper over any seams on the corners. You need to create a smooth, flat surface for the mosaic and provide a clear background for the paint.

2 Paint the outside of the box with the paint or ink. Take the paint just over the insides of the box and lid, too. Allow to dry.

3 On a spare piece of paper, practice drawing different animal heads and leaf designs. You can get ideas from books, but try to make them a good size and keep them quite simple. Draw some leaves over the animal faces, so they look as if they are peeping out of a jungle (see below). Think about where your designs will fit best. Use smaller shapes on the sides and bigger ones for the lid. Plan the colors so that you don't get the same ones next to each other.

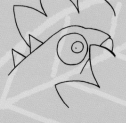

4 Draw your finished design over the box and lid using a light-colored pencil. If you're feeling clever, put the lid on the box and draw the design so that it flows continuously over the box and lid. If not, draw out separate designs and leave a space around the edge of the lid for a border pattern (see tip box). Remember that the lid will cover the top of the sides of the box, so don't draw too much detail there!

(see tip box)

TIP

If you are not joining your images up on the box and lid, decorate the edges of the lid with a simple pattern using two shades of green. Try one of the ones shown or make up one of your own.

5 As with all the projects, do the foreground first, using lighter greens for the foreground leaves and bright colors for the animals. Darker greens will be better in the background to give depth.

6 When you have finished your mosaic, varnish it by painting on a mixture of PVA and water. This is white until it dries and will make the colors look deeper and richer. It will give your box a lovely shine, as well as making it stronger. Hang the box and lid separately over a couple of tall jars so they can dry without sticking to the table. (Don't forget to put down newspaper to catch the drips.)

7 When the PVA varnish has dried, decorate the bottom and the inside of the box and lid. Cut some sticky-back paper into small pieces and make a collage with them so there are no gaps showing. If you can't find this type of paper, use any kind of shiny green paper (or even candy wrappers) and stick them down using PVA.

MAKING LEAVES

1 Use little squares to make clusters of leaves. Starting with a square at the top corner, work around, then move in.

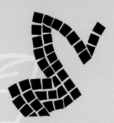

2 Use little strips to make long thin leaves or trailing vines. Start with the outside edges and work inward, cutting the strips as you need to.

3 Make big leaves for the background using big squares. Give some of the leaves holes, so the background color shows through. Lay squares around the outside of the holes as well as the outside of the leaves and fill the spaces in between in whatever way seems most natural!

4 Make leaf stems with a line of thin strips or rectangles.

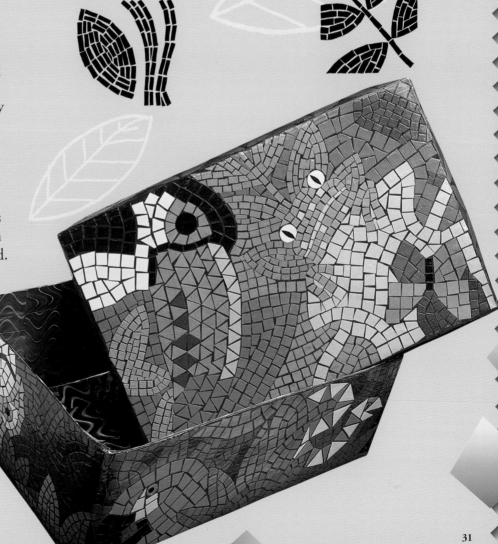

31

MAKING A TOUCAN

1 Cut a big black circle for the eye, glue it down, and surround it with a ring of green squares trimmed to form a smooth circle.

2 Use big squares for the head and strips of different colors, as in the photograph, for the toucan's brilliant beak. Cut the strips into triangles and lay them along the beak, starting at the top. As you reach the bottom, you might have to cut the triangles thinner and flatter to fit.

MAKING A LEOPARD

1 Cut two small black circles for the center of the eyes and lay a ring of small green squares around them. Make one or two of the squares lighter in each eye to make highlights. Cut two squares into two triangles and lay them at either corner of the eyes.

2 Make the nose by cutting a big square into two triangles and placing them back to back. Use lines of black strips for the whiskers with white strips cut to fill the gaps.

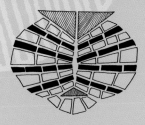

3 Make the ears using a combination of brown squares and triangles and surround them with pink squares that have been cut to fit.

4 Cut out some different sized black circles and lay them randomly around the head. Cut out some small orange squares and work them in around the circles. Start each line from a different point at the bottom of the cheeks to make them appear fluffy.

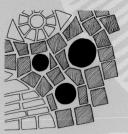

MAKING AN IGUANA

1 Cut out different shades of blue-green and yellow circles using a hole puncher. Cut out a small black circle for the eye and lay long thin triangles of blue all around it.

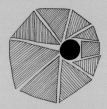

2 Cut out some more circles in the same shade of blue and cut them in half. Lay them in a line to make the iguana's mouth. Fill in the rest of the body using the blue-green circles, occasionally dropping in the odd darker, lighter, or yellow one.

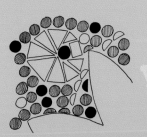

3 Cut out some light yellow triangles to make spines for the iguana's back.

MAKING A SNAKE

1 Cut out a green circle for the eye and lay a thin black "petal" shape on top of it to make the snake's slitty pupil. Cut strips the same width as your snake's body from yellow and pink paper. Cut them as you did for the toucan's beak, but vary them so you get some fat triangles and some thin ones.

2 Glue triangles of alternate colors to fill the snake's body. The fat triangles should go on the fattest part of the snake's curves, so as the curves of your snake change direction, you will have to change the size of the triangles.

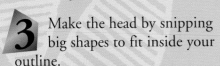

3 Make the head by snipping big shapes to fit inside your outline.

MAKING A BUTTERFLY

1 Cut out big squares in similar shades of blue. Starting with the top wings, lay a square on the outside of the bottom line and work inward, trimming the squares to fit as necessary. Then do the next line up, starting with a full square on the outer edge.

2 Lay the squares for the bottom wings on their points so they look like diamonds. Start with the bottom "point" and work inward and upward as before. Make the butterfly's thin body and head using small black squares.

Magnificent mosaic mermaid

Use all of your newly acquired skills and a variety of materials to create a mosaic picture of a beautiful mermaid surrounded by shimmering fish and waving seaweed fronds.

YOU WILL NEED

- **A large sheet of thick cardboard, painted turquoise green**
- **Tracing paper**
- **Colored paper**
- **Shiny foil paper or holographic paper**
- **Old glossy magazines**
- **Blue, silver, and green circular sequins, plus iridescent or holographic ones, if possible**
- **Star or shell-shaped sequins or real shells**
- **Dried legumes—brown lentils, split peas, small light-colored beans**
- **Transparent glass nuggets**
- **Hole puncher**
- **Scissors**
- **PVA glue and small plastic spreader**

1 You need paper in four different shades of blue for the sea, so you may have to paint some white paper. Make turquoise by adding bright green to bright blue, then slowly darken it using a darker blue. Use a separate piece of paper for each shade.

2 Go through the glossy magazines and cut out pieces of bright orange, lime green, purple, and big chunks of blonde hair.

3 On a photocopier, enlarge the mermaid template on p. 48 and trace it onto the turquoise cardboard (see p. 6).

4 Around the mermaid, draw thin branches of seaweed growing out of a rock. Now draw a shoal of fish swimming diagonally across the picture. If you do them quite big, they will look as if they're at the front of the scene.

5 When you have completed your drawing, arrange a few of the glass nuggets over it, so they look like bubbles. Glue them down.

6 Arrange and then glue down any star or shell sequins (or shells) you are using. You could put them on the sandy sea bottom and the rock, or even over the mermaid's hair.

7 Make the fish out of orange paper cut from the magazines. Cut squares that will be wide enough to cover the fish in just a few rows. Start at the mouth and work along the bottom toward the tail, then repeat along the top. Fill in the space in the middle with specially cut pieces. Make the tail out of triangles and use sequins for the eyes.

TIP

To make the bubbles look shiny, glue circles of silver foil (cut to the same size) to the base of the glass nuggets. Allow to dry for an hour or so and then glue them to your picture.

8 Make the seaweed from little strips of pink or lime green paper cut from magazines. Do the central stem first, followed by the branches.

9 Make the mermaid's glittering tail by cutting out lots of circles from the shiny foil with the hole puncher. Use silver, blue, and green. Starting at the mermaid's waist, glue the circles and circular sequins in an uneven line from hip to hip and work downward.

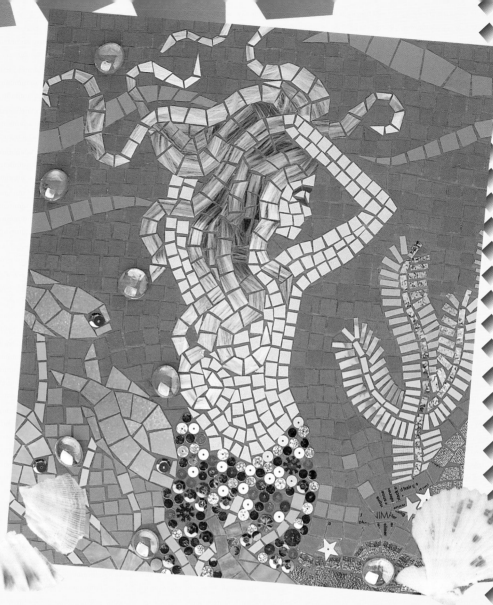

10 Stop gluing the circles just before the tail fin. Glue down five lines of dark blue paper strips on the fins. Then fill in the gaps with the color you have been using for the rest of the tail.

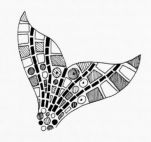

11 Use chunks of blonde hair from magazines to make the mermaid's hair. Cut out squares of paper and glue them down, starting from the top, as you did for the fish. Cut smaller squares as the locks of hair get thinner, and shape them so they fit around the curls. Finish with a pointed triangle.

12 Cut a tiny triangle in dark blue for the mermaid's eyelashes, so it looks as if her eyes are closed. Make her eyebrow out of a couple of tiny strips in the same color. Fill in the rest of the face and body using small squares of pale blue paper.

13 Make the rock out of squares of purple cut out from magazines. Use different shades of purple on different areas of the rock to create the illusion of shifting light.

14 Make the sandy bottom of the sea using a mixture of dried legumes. Place paler ones at the bottom and get darker toward the top. Spread the glue on small areas of the cardboard, and glue the legumes directly onto it. Arrange them so that they flow around the mermaid, fish, rock, and seaweed. Leave an uneven edge where they merge with the sea.

15 Do the water last. Cut small squares from the different shades of blue—only a few of the lighter ones, but a lot of the darkest shade. Start at the bottom on the "rockless" side, gluing the squares in horizontal rows between the legumes, and work up, starting with the lightest blue and gradually getting darker.

16 It will take a bit of time to make your mermaid picture, but it will be well worth the effort. All the different techniques and materials will combine to make a stunning picture, and everyone will be impressed by your amazing mosaic!

TIP

To make a smooth color change, include a couple of squares of the next color on the last line of the one you are using. When you are working with the next color, include a couple of squares of the previous color on the first line.

TIP

Make swirly ripples on the surface of the sea by cutting out a wavy strip from one of the lighter blues, then cutting and gluing the squares down in the same order.

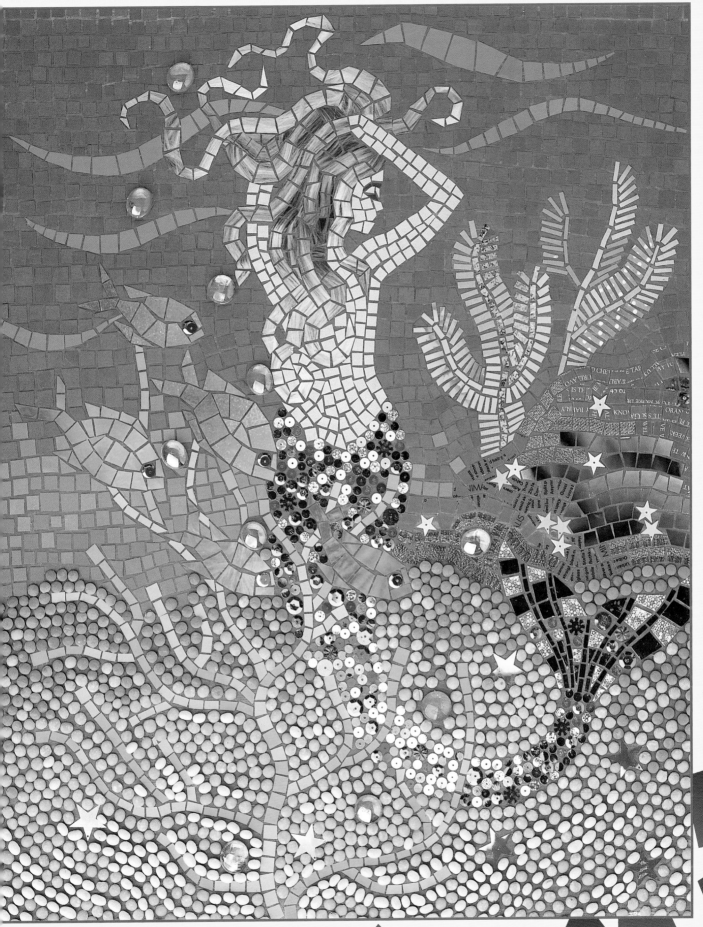

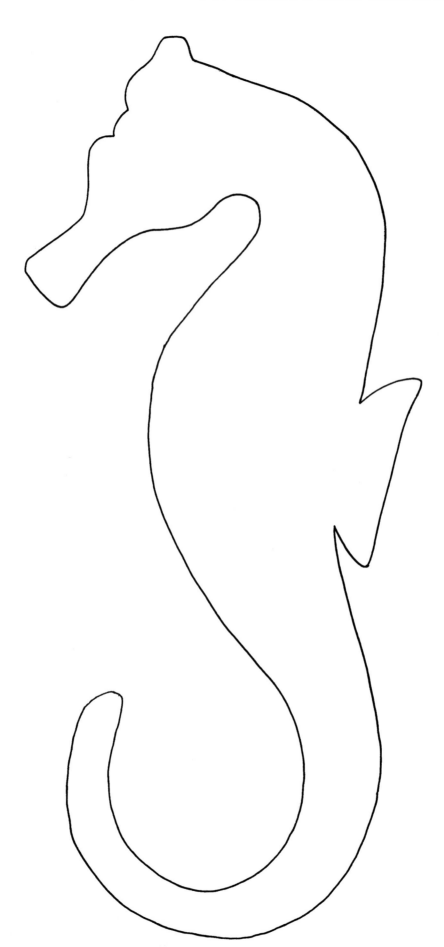

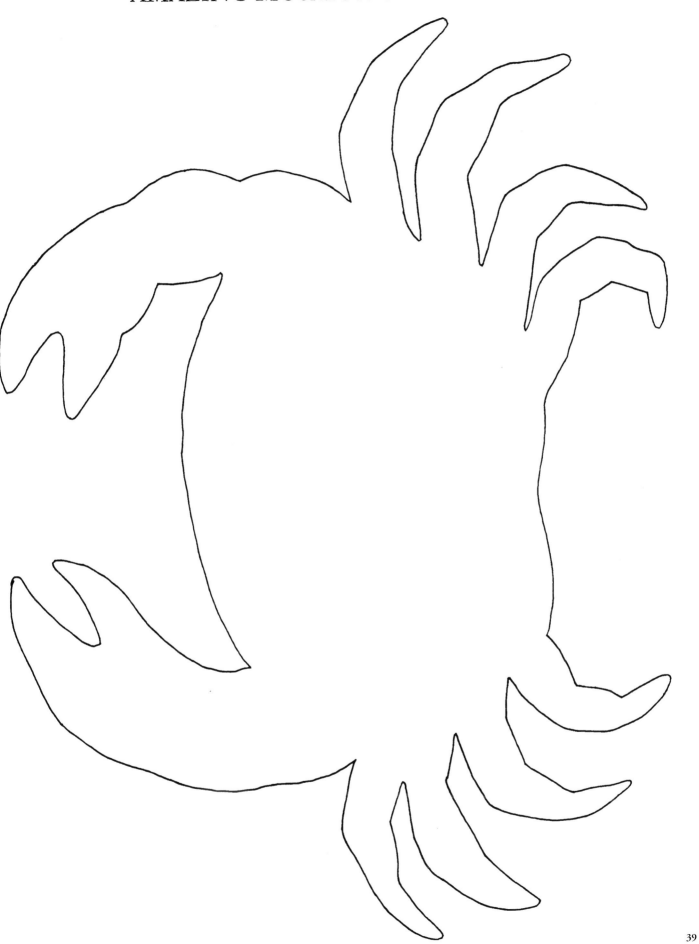

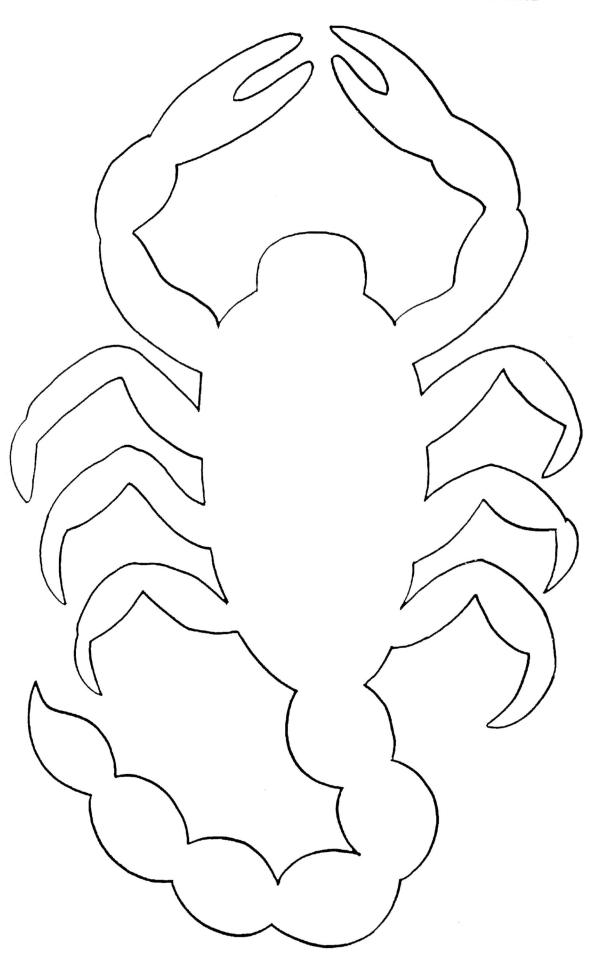

AMAZING MOSAICS: MOROCCAN FRAME TEMPLATE

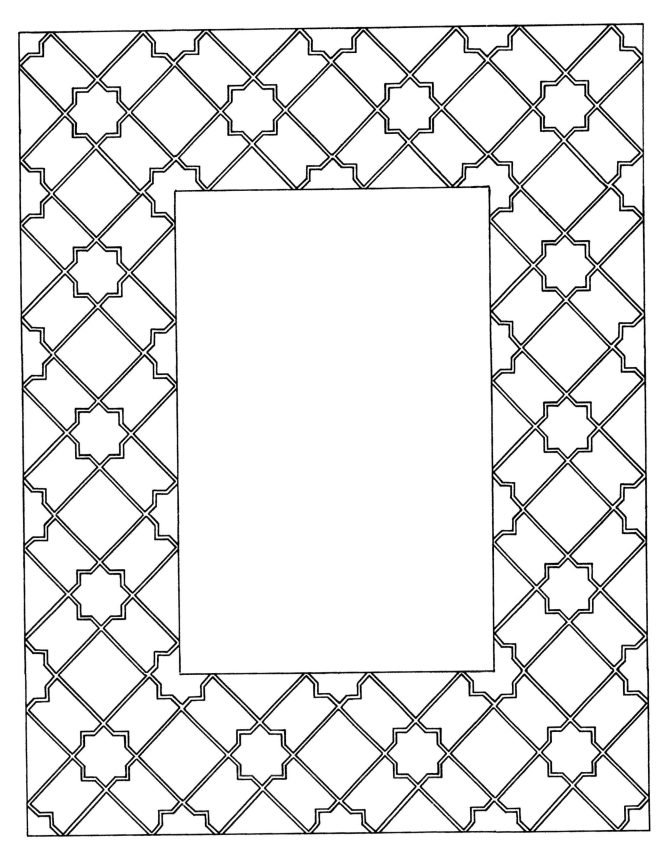

TILE TEMPLATES

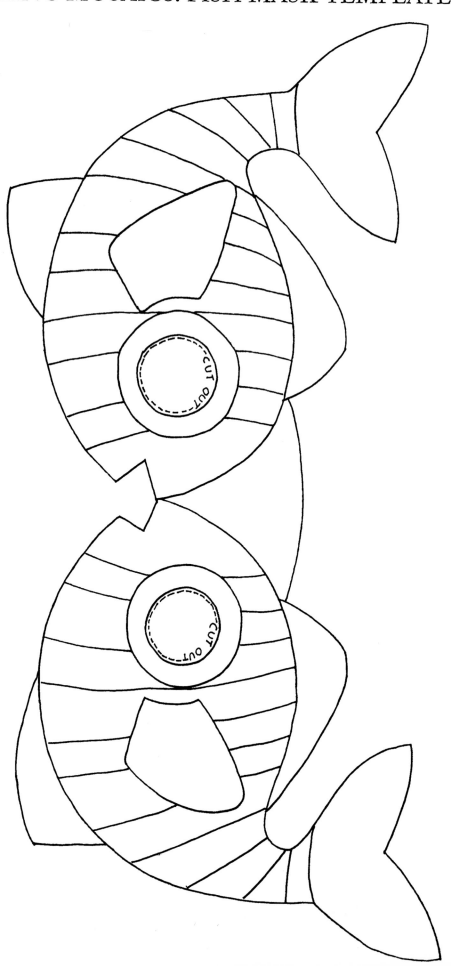

AMAZING MOSAICS: GIRAFFE TEMPLATE

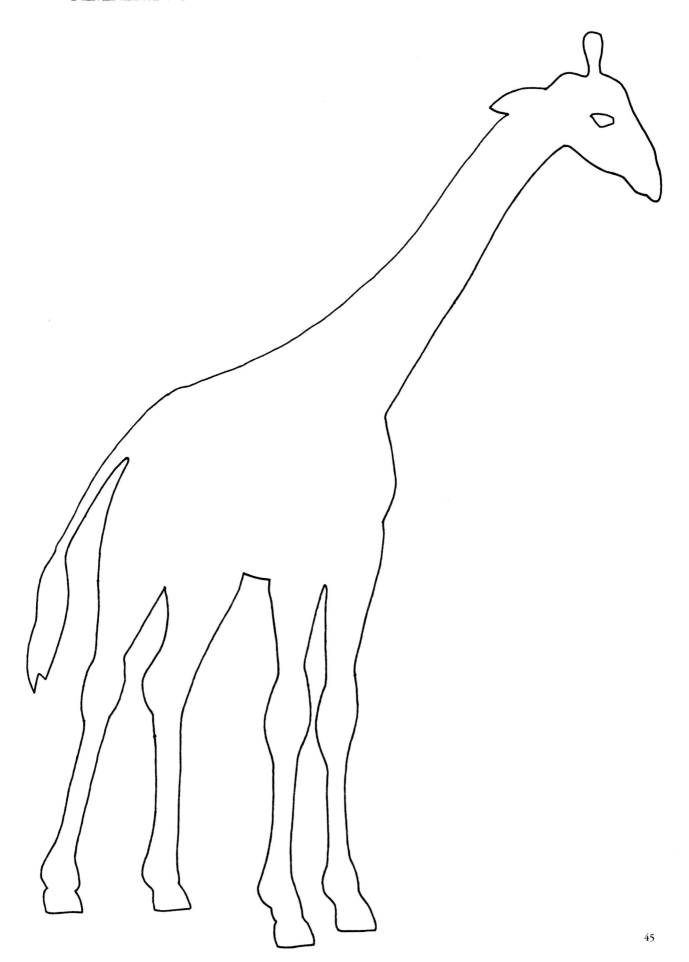

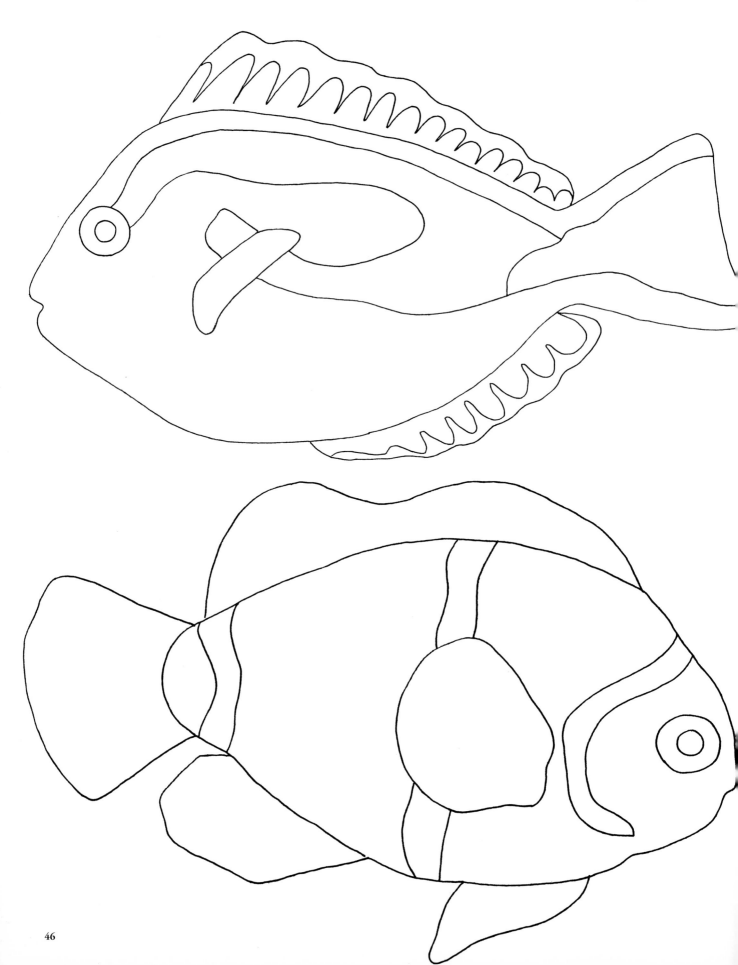

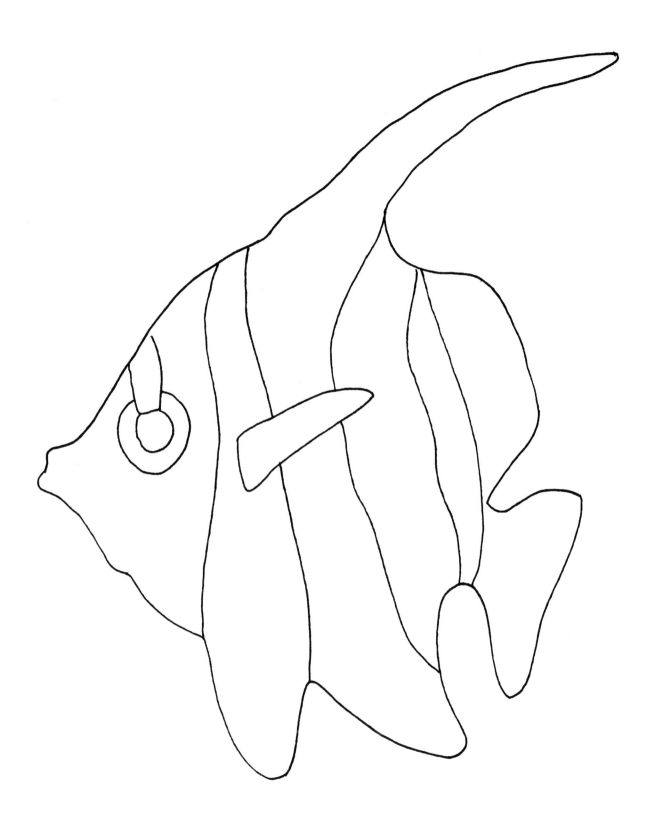

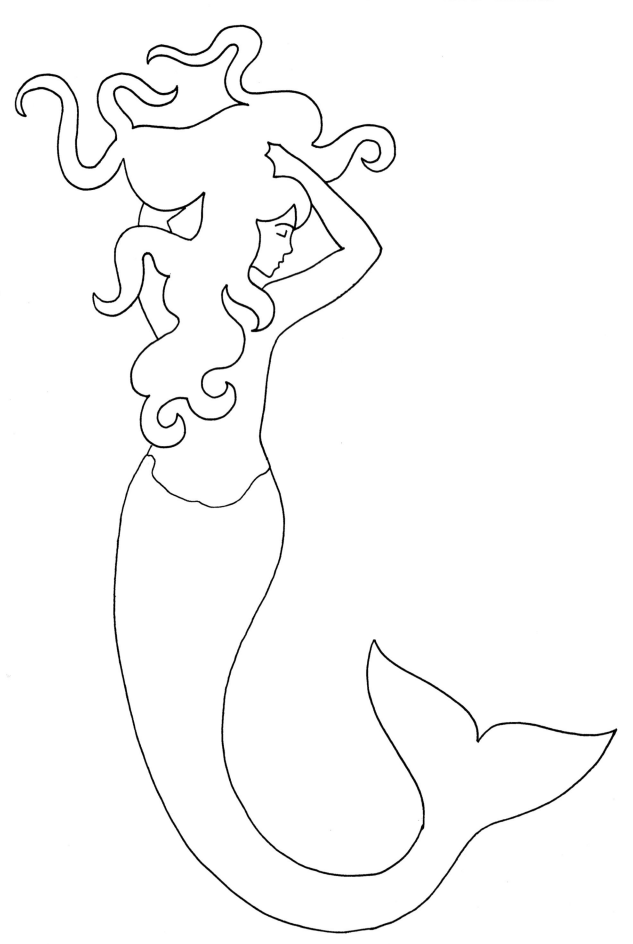